MARGARET BOUR

The Early Work, 192

D0090927

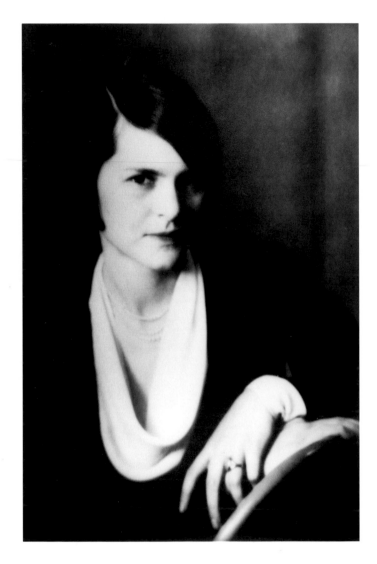

Margaret Bourke-White
Publicity Photograph by Berenice Abbott, ca. 1930

Margaret Bourke-White

THE EARLY WORK, 1922–1930

SELECTED, WITH AN ESSAY, BY

Ronald E. Ostman and Harry Littell

℗

A POCKET PARAGON BOOK

David R. Godine · Publisher

BOSTON

This is
A Pocket Paragon Book
first published in 2005 by
DAVID R. GODINE · *Publisher*
Post Office Box 450
Jaffrey, New Hampshire 03452
www.godine.com

Essay copyright © 2005 by
Ronald E. Ostman and Harry Littell
Photographs copyright © by the Estate of
Margaret Bourke-White

All rights reserved. No part of this book may be used
or reproduced in any manner whatsoever without written
permission from the publisher, except in the case of brief excerpts
embodied in critical articles and reviews. For more information,
please write to Permissions, David R. Godine, Publisher
9 Hamilton Place, Boston, Massachusetts 02108.

LIBRARY OF CONGRESS
CATALOGING-IN-PUBLICATION DATA
Bourke-White, Margaret, 1904-1971.
Margaret Bourke-White: the early work, 1922/1930 / selected,
with an essay, by Ronald E. Ostman and Harry Littell.— 1st ed.
p. cm. — (A pocket paragon book)
ISBN-13: 978-1-56792-299-8 (pbk. : alk. paper)
ISBN: 1-56792-299-6 (pbk. : alk. paper)
1. Photography, Artistic. 2. Pictorialism (Photography movement)—
United States. 3. Bourke-White, Margaret, 1904-1971.
I. Title: Early work, 1922-1930. II. Ostman, Ronald Elroy.
III. Littell, Harry. IV. Title. V. Series: Pocket paragon series.
TR653.B676 2005
70'.92—dc22
2005013367

FIRST EDITION
Printed in China

for

Nancy L. Ostman

&

Patricia Fox

BEFORE FORTUNE

Margaret Bourke-White's Early Photographs

FRESH FROM CORNELL IN 1927, a twenty-three-year-old Margaret Bourke-White pounded the pavements of Cleveland on the trail of a handful of professional connections. Her wardrobe was sparse and her one pair of shoes was run down at the heels. She owned little photographic equipment and boasted little technique. Her tiny studio apartment doubled as her darkroom. Eager to succeed in a profession populated mostly by men, she counted on admirers and friends for technical assistance and financial support.

One thing bolstered her confidence – the portfolio she carried. There, carefully mounted, were the photographs she had taken during her senior year at Cornell University. They were striking – bold, self-assured compositions in the impressionistic pictorialist style then in vogue – misty campus landscapes, soft-edged interiors, cascading waterfalls. Those portfolio images, today virtually unknown, opened doors and helped her to obtain her first commercial assignments. In less than a year she would be a successful photographer, selling images of Cleveland's industrial world for $100 apiece. Within a decade she would photograph the famed inaugural cover and lead essay for *Life* magazine. Margaret Bourke-White would become a household name.

The photographs Margaret made during her college years are notably different from the images that characterize her mature work. The style she adopted as a beginning photographer – pictorialism – had dominated the field of fine-art

photography for more than two decades. It was championed by Clarence H. White, her first formal photography instructor. Margaret rose very quickly to the heights of world-class photography, and as she prospered and developed her own distinct style, she rejected pictorialism vehemently.

Looking at these little-known images of harmony and beauty – now housed in the Cornell and Syracuse University archives – it is easy to forget that Bourke-White created them during a period colored by personal confusion and pain. A deeper understanding of her early life and work provides new keys to unraveling Bourke-White's rise to success as a major twentieth-century American photographer.

A plain little girl with a face too old for a young child . . . a bit plump [with] her long hair severely parted in the middle and pulled back into pigtails. Her face was exceptionally broad, her jaw what is called determined. She was very shy, a trifle solemn, often alone [but] she was smart.

<div align="right">

– VICKI GOLDBERG
Margaret Bourke-White:
A Biography

</div>

Margaret White was born in 1904 in New York City, the second daughter of Joseph and Minnie White. Her father, on whom she doted, was a withdrawn and taciturn mechanical genius who tinkered endlessly with printing presses, automobiles, and cameras. Throughout her life, Margaret seemed reluctant to reveal the origins of her interest in photography. She apparently wanted others to think of her talent and abilities as a natural expression of an inborn gift. Yet we know that her father was an avid photographer

who had a special interest in optics and chemistry and that, as a child and adolescent, Margaret assisted him in visual composition and photochemical development tasks. Her mother, trained as a stenographer, never worked outside the home. Minnie was dedicated to self-improvement for herself and her children. She expected her two daughters and son to adhere to strict rules of behavior: no slang, no chewing gum, no comic books or funny papers, no flashy clothing. Minnie gave the children a practical upbringing. All three learned to sew and to cook.

The household was essentially secular, though tinged with Christian overtones. Joseph White was brought up as an Orthodox Jew, a faith he would later renounce. Minnie White was of Anglo-Irish extraction. She and Joseph espoused Ethical Culture principles: rational behavior and self-control. Joseph and Minnie's children knew nothing of their Jewish heritage until they were adolescents. While they were growing up, Joseph's family rarely visited them, perhaps because Minnie harbored anti-Semitic attitudes.

Influences outside the family during Margaret's preschool years were few. Minnie vetted and approved Margaret's visits to select playmates. For his part, Joseph insisted on quiet. Preoccupied with his engineering and mechanical tasks, he could not be disturbed. It was a silent home. Margaret, shy and lonely, became absorbed in a fantasy world of costume dress-up and private play-acting. She was a princess. She quizzed Minnie about royal behavior, and her games incorporated daydreams of dancing at dress balls and of holding court on a throne before an audience of fawning attendants.

When Margaret was a child, the family moved to

Bound Brook, New Jersey. Though close to New York City, the town at that time was surrounded by pristine country-side, and Joseph frequently took his younger daughter on nature walks. Margaret learned to identify various species of snakes, to understand their environmental role, to know which were not poisonous, and to be amused by their sham displays of threat. She learned how to handle and feed them, keeping them as pets in pens her father built.

Margaret attended a four-room elementary school in Bound Brook, and for her natural science class she brought her beloved menagerie to school. She thought it strange that most of her playmates feared and were repulsed by her reptilian friends. Still, along with her snakes, she became a center of attention. It was a sensation she had never experienced, and she realized she enjoyed it.

For years Margaret repeated her snake-charmer routine whenever she wanted to shock or make an impression.

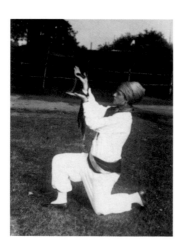

Margaret White as a Snake Charmer, early 1920s

It was a guaranteed crowd-pleaser she could use to break the ice in new social settings. Well into her career as a free-lance advertising photographer and half-time *Fortune* magazine photographer, her reptiles (now turtles and alligators) lived on display in her sixty-first-floor studio in New York's Chrysler Building.

No mere eccentricity, Margaret's fascination with snakes reveals how desperately she craved attention, even notoriety. The reptiles were necessary, if exotic, props – but then she found something that worked even better and paid well: photography. Like her display of slithering creatures, Margaret Bourke-White's photographs were noteworthy for their strong individual style. Photography also satisfied a growing taste for the limelight, casting her in the role of creative genius. As *Life* magazine's star photographer in the mid-twentieth century, she would reach an audience of more than five million viewers every time her images were published.

Past the shyness, loneliness, and anxieties she had experienced as a child, Margaret suffered the adolescent traumas of her father's periodic illnesses and of her own unpopularity in high school. She fought back against despair and depression with intellect, imagination, and focused energy. Encouraged by her teachers, she won a literary contest, joined the debating club, appeared in school plays, and edited a school publication. Despite these highlights, she would remember her high school years unhappily.

The summer after high school, Margaret studied dance at Rutgers University. In the fall of 1921 she began art studies at Columbia University. A half-year later her father

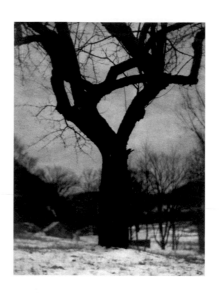

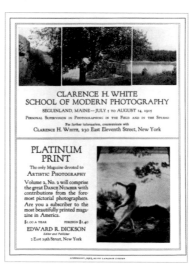

top: Clarence H. White: The Tree–Winter, 1919–1924
above: Advertisement, Clarence H. White School of
Modern Photography, 1915

suffered a fatal stroke. His death left the family in a precarious financial condition, but there was just enough money for Margaret to complete the spring semester of her freshman year at Columbia. And it was there that she came into contact with Clarence H. White, a leader of the Photo-Secession, the photographic movement that propounded pictorialism – artistic effects rendered in gauzy soft focus and with moody atmospherics.

White had made the transition from gifted solitary photographer to teacher of photography. Though affiliated with Columbia University's Teachers College, he also offered instruction from his studio home. Margaret was largely attracted to White's course for its emphasis on design and composition – but she also saw participation as a tribute to her late father and his love for photography. Minnie White somehow managed to find the $20 – an enormous sum in those days – needed to buy Margaret a 3¼ x 4¼ Ica Reflex camera that had a cracked lens. Unlike popular Kodaks, it required more than average aptitude to use. Margaret's surviving negatives made with the Ica are on glass, an antiquated medium even in 1922.

White taught his students that good photographs were meticulously planned and controlled, that abstraction and patterns were important, and that artistically successful photographs required balance: dark against light, shape against shape, solids against voids – an aesthetic that dominated American fine-art photography from 1899 through the 1920s. White's classes also discussed photography as a tool of commerce and advertising. Though these pursuits confounded pictorialist notions of high art – manufacturers wanted crisp, uncluttered images to tout their products

and services – many of White's students would eventually reconcile these conflicting motives and go on to earn substantial livelihoods with their cameras, Margaret among them. She would later invoke White's mantra of "design, design, design" and recall him with affection as a "great teacher."

Margaret spent the summer after her freshman year at Columbia as a photography and nature counselor at a children's camp in Connecticut. There she concocted a modestly successful scheme to make photographs to sell to campers and tourists. The proceeds fell short of what she needed for tuition at Columbia, but the money crisis was solved by brother-and-sister philanthropists who knew her intimately. They were convinced she'd make something of herself if given the chance. Thus eighteen-year-old Margaret was able to transfer to the University of Michigan in the fall of 1922. She initially had hoped to study herpetology, yet soon drifted back to photography, taking pictures

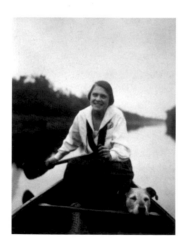

Margaret White at Camp Agaming, Lake Bantam, Connecticut, ca. 1922

of campus buildings for the *Michiganensian* yearbook and working in the darkroom at the university's museum.

But Margaret's emotional life was collapsing. Chronically depressed, she suffered a nervous breakdown in the summer of 1923. She began therapy and returned to Michigan in the fall of that year, but she had several relapses. Depression robbed her of sleep, nearly paralyzing her.

There was one glimmer of hope. The previous school year, she had met Everett "Chappie" Chapman, a twenty-three-year-old student whose serious demeanor reminded Margaret of her father. Margaret "confessed" to her therapist and to Chappie that she was half Jewish. This apparently relieved her mental state and she was able to carry on, despite her psychiatrist's diagnosis of an inferiority complex.

On the last day of her nineteenth year – chosen by the iconoclastic couple because it was Friday, the thirteenth – Margaret married Chappie. Although the couple eventually drifted apart, the marriage would prove to be a decisive influence on her life and photography. Chappie was a photographer of considerable technical ability, and for a time the two of them worked as a team, photographing fraternity parties, sorority soirées, and graduations. Given her compositional talent and Chappie's darkroom expertise, it is probable that they divided the labor along those lines. Indeed, within a few days of their wedding, it must have been Margaret who made a most remarkable photograph. The image depicts the angular structures of a loudspeaker system (p. 25). Short of the sheer pleasure of its abstract, sculptural forms, there was no known reason for Margaret to have taken this striking photograph. There surely was no reason to expect that any potential customer would be

 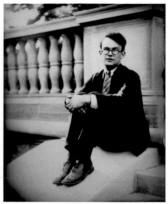

left: Margaret White, University of Michigan Library Steps,
ca. 1924 by Everett "Chappie" Chapman (attr.)
right: Everett "Chappie" Chapman, University of Michigan
Library Steps, ca. 1924 by Margaret White (attr.)

interested. Still, it anticipated the industrial images she would make in the late 1920s for Cleveland clients and in the 1930s for *Fortune* magazine, images that would solidify her reputation as a major American photographer. But for the time being, she and her new husband retreated to their darkroom, no doubt one of the strangest places on record to spend a honeymoon. Chappie's technical acumen proved invaluable to his wife, who worked at his elbow preparing prints for clients.

A poster for a May 1924 campus show of Chappie and Margaret's work was adorned with enigmatic drawings of owls. It seems safe to assume that owls had some personal or professional significance for Margaret, who rarely did anything visual that was unpremeditated. The couple also hosted private showings of their university photographs.

The resulting sales proved how well husband and wife complemented each other as a professional team. While Chappie's strengths were largely technical, Margaret explored new, dramatic visual ground using her expanding intuitive grasp of design, composition, and lighting.

The May 1924 exhibit solidified Margaret's credentials as an artist, at least in her own mind. She signed what she considered her best images with a stylized "MB White." The "B" was taken from her mother's maiden name, Bourke; only later would Margaret add the hyphen. Included in the show was her intriguing photograph of a short-wave oscillator in a science laboratory (p. 15). Like the loudspeaker image, it seems to have been made more as an exercise than as a saleable image. It can be read as a tribute to her new husband or as an homage to her father. Whatever the reading, it does seem to celebrate the system-

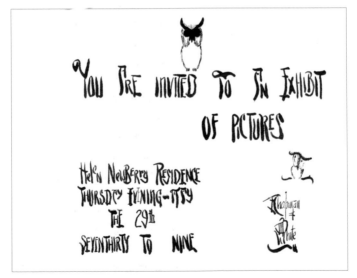

Photography Exhibit Poster, Everett Chapman and Margaret White, University of Michigan, May 29, 1924

atic, rational, and objective process of scientific inquiry.

Margaret's photography at the University of Michigan concentrated on architecture and landscaped lawns. She favored trees, fog, reflections, shadows, repetitive patterns, extreme angles, and clouds, all portrayed in standard pictorialist soft focus. She often made multiple negatives of a scene in pursuit of a particular effect. The images underscored Margaret's goal of careful composition. Her photographic records indicate patient scrutiny of lighting effects, often obtainable only near dawn, at dusk, or at night. Margaret's time at Michigan saw the development of several key themes and metaphors that would recur throughout her career.

Of Margaret's photographs at the University of Michigan, biographer Vicki Goldberg wrote: "She worked hard on her photographs that year, lying in wait for shadows, intent on simplifying compositions, and fired up with the romance of stormy skies, ragged clouds, and the moon struggling to shine through. She made up a portfolio: architecture, portraits, and images she had coaxed from the thick Ann Arbor fog."

Margaret's dedication to her photography revealed the beginnings of a rift with her husband. Chappie, who hoped to become a prominent scientist, ultimately treated photography as a sideline. More crucially, his dependence on his mother – actively cultivated by Mrs. Chapman – undermined the marriage. Jealous of Margaret's new role in her son's life, Mrs. Chapman joined the young couple on their delayed honeymoon at a lake cottage. As soon as Chappie was out of earshot, she accused Margaret of stealing her son. Mrs. Chapman said she never wanted to see her again.

Margaret fled in a tearful panic, walking seventeen miles to Ann Arbor.

Chappie's mother interfered continually, peppering them with whining letters of complaint that made them feel guilty and neglectful. Chappie would lapse into long silences and ignore Margaret.

In September 1924 Margaret and Chappie moved to Purdue University, in Indiana, where Chappie had been hired to teach engineering. To supplement their income, Margaret set up shop as a commercial photographer, shooting sororities and other campus groups. At the same time, she enrolled in a paleontology course. As a faculty wife, however, she felt isolated from her fellow students. In December Margaret discovered she was pregnant. Before her marriage she had dreamed of having Chappie's child, but now she understood the union was not stable enough to sustain a family. She arranged an abortion.

In 1925 the couple moved to Cleveland. Chappie had taken a job with the Lincoln Electric Company, and Margaret accepted a teaching post in the city's Museum of Natural History, studying nights in the education department at Western Reserve University. Chappie had become increasingly moody. Margaret was assailed by recurring bouts of depression. Faced with her husband's indifference and isolation, she felt unable to save the marriage. She decided to separate from Chappie and left Cleveland for upstate New York.

Striding across the old campus quadrangle ... she wore a magenta hat, a crimson coat with fuzzy fur and she swung

along the crosswalk with her left arm waving behind her like a rudder. . . . I saw her eyes . . . deep Irish, capable of going into Scotch mists of tenderness and they surmounted a wide smile.

— SAM HORTON,

a Cornell classmate

In her twenty-second year she enrolled in yet another university, Cornell, set amid the vineyards, gorges, and rolling farmland of the state's Finger Lakes region.

"Starting with me," Sam Horton remembered, "Peg captivated plenty of men on the campus, and none of these affairs lasted long, because to Peg White, the job, the art she had in her mind, always transcended the interest she had in any individual male. . . . She took pictures of the campus that knocked the spots off anything that photographers twice her age had achieved." Horton remembered once holding her legs as she shot photographs from the top of a soaring Cornell tower. He also recalled watching her leap around the edges of Cornell's deep gorges with the aplomb of "a sure-footed mountain goat."

Her old Ica camera assumed the role of trusted and familiar friend. To pay her way – supplemented by loans – Margaret began making campus images as she had at Michigan. "Here I was in the midst of one of the most spectacular campus sites in America," she would write, "with fine old ivy-covered architecture and Cayuga Lake on the horizon and those boiling columns of water thundering over the cliffs and down through the gorges. Surely there would be students who would buy photographs of scenes like these." Her pictorialist training was particularly well suited for a university clientele – students and alumni,

looking back with nostalgia to campus strolls and activities within picturesque gothic buildings. Margaret took enormous care over her exposures, always choosing times and locations for the special lighting they offered. Again, she signed some of her images, presumably those she considered the best, with her stylized "MB White."

In the range of Margaret's Cornell images, we can see the work of a budding professional. The photographs boast the strong composition and lighting essential to her sense of artistic design. Margaret made no bones about her reliance on soft focus. "In those days to be artistic," she would write, "a picture must be blurry, and the exact degree of blurriness was one of the features over which I toiled during the long nights in the darkroom, diffusing, printing. . . . When I opened my little sales stand outside the dining hall in Prudence Risley Dormitory, my pictures on display looked as much like Corots as my old cracked camera lens plus some sheets of celluloid had been able to make them. And if I heard some admiring student murmur, 'Why these don't look like photographs at all,' I took it as a compliment."

Margaret was becoming adept at marketing her work. Prices ranged from 25¢ for a small contact print to $1 for a 5 x 7 or an 8 x 10, to $3 for an 11 x 14. In time, Margaret hired a sales staff to hawk prints to students. And she found additional outlets: The *Cornellian* yearbook and the weekly *Cornell Alumni News* bought several images. An enthusiastic editorial staff gave her images colorful captions; below Margaret's shot of her dormitory, Risley Hall (p. 40), for example, they wrote: "Snow Encrusted Battlements. Across from Sibley, the towers of Risley rise above the gorge like

those of an ancient castle." Margaret ran an ad in the February 1927 issue of the *News* offering sixteen of her campus views at $1 each. Interestingly, the ad closely resembled one used in 1915 by Clarence White for his New York photography school. The tone of Margaret's photographs often echoed White's, as well.

Margaret's work eventually caught the attention of the university's architecture faculty. She was soon offered – and gladly accepted – commissions to photograph faculty homes and children, even family dogs and cats. She also made images of walks, stairs, gardens, and diffusely lit interiors. Margaret's longstanding interest in biology is evident in her many photographs of trees in full leaf, ivy, and lush plants. This small-scale success reinforced her interest in a career in architectural and estate photography.

Margaret also was busy with a spate of other projects: publicity stills for a theatrical group (p. 73) and portraits for

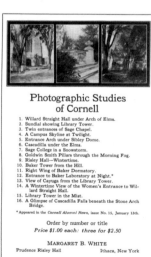

Photographic Studies of Cornell

1. Willard Straight Hall under Arch of Elms.
2. Sundial showing Library Tower.
3. Twin entrances of Sage Chapel.
4. A Campus Skyline at Twilight.
5. Entrance Arch under Sibley Dome.
6. Cascadilla under the Elms.
7. Sage College in a Snowstorm.
8. Goldwin Smith Pillars through the Morning Fog.
9. Risley Hall—Wintertime.
10. Baker Tower from the Hill.
11. Right Wing of Baker Dormatory.
12. Entrance to Baker Laboratory at Night.*
13. View of Cayuga from the Library Tower.
14. A Wintertime View of the Women's Entrance to Willard Straight Hall.
15. Library Tower in the Mist.
16. A Glimpse of Cascadilla Falls beneath the Stone Arch Bridge.

* Appeared in the *Cornell Alumni News*, issue No. 15, January 13th.

Order by number or title
Price $1.00 each: three for $2.50

MARGARET B. WHITE
Prudence Risley Hall Ithaca, New York

Advertisement for Margaret B. White's Photographic Studies of Cornell, 1927

individuals, sororities, and clubs (pp. 69–70). Knowing how well graduation photographs had sold at Michigan, Margaret skipped her own commencement exercises so she could make graduation photographs of fellow students and take orders for prints (p. 68). Before leaving Cornell she arranged to make her campus photographs available to future students and the general public through the campus bookstore.

Variant prints from a single negative, like the pair of Willard Straight Hall prints (pp. 46–47), reveal how Margaret transformed sharply focused images into pictorial soft focus in the darkroom. In this case much of the effect was created in the enlarger by exposing the print through "sheets of gelatin to make the pictures more blurry and more artistic." Other pairs show her thinking and composing an image in camera: two drastically different impressions of Baker Tower (pp. 54–55) were captured by moving the camera from an oblique angle, with the building itself underexposed, to a straight-on angle featuring a foreground tree, less fence, and fewer vehicles. The shift places more attention on the building and its archway. By positioning the tower lower in the composition, she gave greater emphasis to the clouds, drawing attention away from the hill beyond the tower. Her images of Boardman Hall, Jennie McGraw Tower, and Uris Library (pp. 60–61) also reveal how Margaret improved compositions by shifting the camera's location. In the first image, the dominant impact is achieved by dense tree foliage, but the tower is partially obscured, and a fire hydrant spoils the mid-ground view. In the second, Margaret has moved the camera forward and to her left, strengthening

the composition by allowing foliage to arch over the top of the tower, emphasizing the tree trunk as a framing element, and eliminating the hydrant and a foreground path. As she had done at the University of Michigan, she took photographs in all seasons and types of weather, and at all times of day and night.

Much as Michigan's bridges would find their echoes in Margaret's early freelance work in Cleveland, her Cornell photographs contain early instances of stylistic conventions and compositional motifs that Margaret would use throughout her career. The image of Cayuga Lake seen through an iron grille high atop Library Tower (p. 31) is echoed in her 1928 photograph taken through a Williamson Building grille above the crowd at Cleveland's Terminal Tower public square, and in her view of the Hotel Cleveland and Terminal Tower (p. 85).

Margaret had also begun working in series. Sequential images of Jennie McGraw Tower (pp. 57–65) and Baker Tower (pp. 53–55) and later the Terminal Tower in Cleveland (pp. 84–87) suggest that she was interested in portraying the towers as icons of their time and place. Margaret captured their grandeur from different locations and at different times of the day and year. The realization that the public was enormously interested in the buildings and would pay for iconic images no doubt added to her fascination with them as places of height, majesty, and power (later, she would add the Chrysler and Empire State buildings in New York City). Margaret also liked to flaunt her apparent nerves of steel and her complete lack of fear of heights. As she traded Cornell's Jennie McGraw Tower for ever taller icons, she made sure she was photographed for

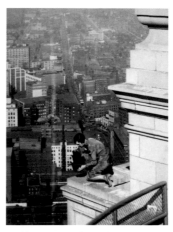

*Publicity photograph of
Margaret Bourke-White
working at the Terminal Tower,
Cleveland, 1928–1929*

publicity purposes as a daredevil on location. She some-
times wore high heels on the wooden planks of scaffolding
above the city streets as she photographed workmen hoist-
ing and riveting steel beams. On one such shoot, the wind
was blowing so hard that three men were needed to steady
her tripod.

Americans of Margaret's era saw little conflict between pris-
tine nature and the industrial landscape. Her photographs,
in fact, locate interesting visual parallels between the two
subjects. The flowing frozen streams and waterfalls in
Ithaca's Fall Creek and Cascadilla gorges found their echo
in rivers of molten steel in the bowels of Cleveland's Otis
Steel Mill (pp. 76–77, 79, 83).

Despite her considerable accomplishments as a land-
scape and architectural photographer, Margaret displayed
only indifferent skills as a photographer of people at this
phase of her career. While she later would be known for
her humanitarian portraits and action images of crowds,

her most noteworthy campus photographs were largely devoid of human figures. When people did appear, they usually were minuscule. She used them (as she later admitted) for purposes of scale.

At Cornell, Margaret was widely recognized for her talent. She knew that the enthusiasm of her clients, especially the faculty and administrators associated with the architecture curriculum, could be parlayed into further commissions. She also knew that notoriety was accompanied by money. Her photographs dating from this period were remarkably precocious, as good as those of any young pictorialist alive. But they would not bring her the unqualified praise and wealth she craved. Cornell set the stage by helping her to make career decisions – she would be a photographer, not a herpetologist, biologist, or educator. She would have a career, not a conventional marriage. Armed with a convincing portfolio of powerful photographs, she was well placed to enter the wider world of lucrative commercial jobs and high-profile commissioned work.

I remember when you came to my office with an introduction from my good classmate, Foster Coffin. I was pleased to recommend you to some of the better architects in Cleveland. Among them was my fellow contemporary and neighbor, Philip L. Small. He was professional advisor for the Van Sweringen Brothers and the men "up the river."

– CHARLES C. COLMAN

Margaret and Chappie did not divorce until she had graduated from Cornell and moved back to Cleveland to launch an independent career. After graduation, Margaret traveled

by Great Lakes night boat from Buffalo to Cleveland. In a diary entry for December 6, 1927, she boldly declared, "I want to become famous and I want to become wealthy." Not only did she dream it, she meant it, and she set out to achieve it.

On her way to Cleveland, Margaret carried an important letter of introduction – for her, one of the keys to fame and riches. In it, Cornell administrator Foster Coffin, class of 1912, addressed classmate Charles C. Colman. Coffin and Colman helped her make contact with architectural clients and a broader network of industrialists and financiers to whom her portfolio would demonstrate her abilities. Most important, Margaret gained access to the Van Sweringens, railroad potentates and real estate developers. Their Terminal Tower signified their bullish belief that Cleveland merited a modern skyline.

On her own time and at her own expense, Margaret carried out an extensive series of photographs of the Tower and of local industrial subjects. She spent weekends prowling the Cleveland flats, exposing sheet after sheet of film: river barges, bridges, exteriors of smoky steel mills, railroads and locomotives, and other industrial landscapes. Back in her tiny studio apartment, nights were devoted to developing film in her kitchen sink, printing enlargements in her breakfast nook, and washing the final prints in her bathtub.

During those first months in Cleveland, while she was trying to build her client list, she faced serious setbacks. Though she was attractive and had no lack of suitors, Margaret's self-esteem was constantly in need of bolstering. She surrounded herself with men eager to be of service,

whether it was fixing a parking ticket or working all night to get out a photographic order to waiting clients.

She saw enough money trickle in to keep the "Bourke-White Studio" afloat. Architectural photographs brought $5 each. Her first coup – a cover shot used by *The Clevelander* magazine, published by the Chamber of Commerce – yielded $10. By November 1927, with the help of public relations men, she could regularly count on $50 fees for covers and photo illustrations of industrial subjects to *Trade Winds*, a monthly magazine published by the Union Trust Company.

She had left Cleveland as Mrs. Everett Chapman in September 1926. At Cornell, she had resumed her earlier life as Peg White, but continued to use MB White as her professional signature. When she returned to Cleveland a year later, she was ready to reinvent herself again. She divorced Chappie and formally adopted her professional name – Miss Margaret Bourke-White. A new identity was necessary for her goals. The hyphen, too, was an important step in the molding of her image. It hinted broadly of good breeding.

By late 1927, Margaret's daytime schedule – filled with assignments for architectural and estate photography – would have been exhausting for most photographers. Beyond that, she spent nights and weekends making industrial photographs. The daytime work garnered worthwhile commissions and Margaret was reasonably content with the artistic caliber of her work. But industrial photography provided a way to rekindle her father's memory. Machinery in the workplace had inspired him and Margaret found that it also stimulated her passion and zeal.

Before the end of the year, Margaret's diligence and her friends' assistance paid off. The extraordinary raw drama of America's productive might captured in her off-hours photographs won the admiration of the Van Sweringen brothers. They put her on their payroll and gave her complete freedom to photograph their empire. A steadily increasing income allowed her to move into a twelfth-floor Terminal Tower studio apartment in March 1928, just six months after returning to Cleveland. All the while, her images of the homes and estate gardens of the wealthy appeared in regional newspapers and national magazines (*House and Garden*, *Architecture*, *Architectural Record*) bringing her a wider, appreciative audience.

Another turning point arrived when her connections gained her permission to photograph inside the Otis Steel Mill. She talked fast to convince a doubtful company president. He warned her that the last woman who visited the mill had promptly fainted from the heat. Margaret assured

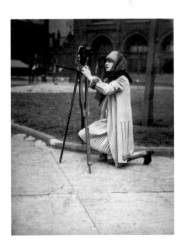

Margaret Bourke-White setting up her camera and tripod in Public Square, Cleveland, 1928–1929

him she was made of more durable stuff. However, the young woman, so brassy and cocksure of herself on the outside, was inwardly frightened, anxious, and unsure of her equipment and technique. Five months of sheer persistence, lavish outlays for film and paper, and inventive application of materials and techniques – not to mention abundant assistance from photographic industry friends – were essential to the success of these pioneering photographs. They were so successful that she sold eight prints at $100 each to the mill president, who asked her to make yet more. The series culminated in *The Story of Steel*, an expensively printed book for the mill's corporate clients. One image of a 200-ton ladle entitled "Romance of Steel" won a Cleveland Museum of Art first-place photography award in May 1928.

Margaret did not invent industrial photography, nor was she the first to stumble on the subject matter. She followed precisionist Charles R. Sheeler, Jr. and like-minded artists in exploiting the artistic promise inherent in the "machine age." Collectively, they adopted a "machine esthetic" to celebrate it. Margaret increasingly came to rely on the second emphasis of Clarence H. White's School of Photography, the one that catered more to advertising and public relations careers than to the art salons and exhibition galleries. As she took on more advertising and public relations work, she gradually abandoned pictorialism in favor of a sharply focused, well-lit "straight" approach, a style that was increasingly esteemed by the expanding ranks of photojournalists and documentary photographers among whom she later would star. While she renounced pictorialism and its gossamer sentimentality, Margaret's

photographs would still retain a strong sense of artistic design. It was as if – to use the language of painting – she moved away from impressionism into abstraction, art deco, and cubism. In certain transitional images that should be counted among her best, both a romantic aura and the mighty majesty of geometrical industrial strength can be glimpsed simultaneously. Her Terminal Tower and High Level Bridge photograph (p. 84) is an outstanding example: it employs moody, cloudy atmospherics to suggest a grandeur and sense of power of the type normally reserved for images of Moses on Mount Sinai.

The Terminal Tower image would have been the sort of image Ralph Steiner disdained in the years after he encountered Margaret as a fellow student in White's classes at Columbia. In 1922, the young Steiner produced a pictorialist book portraying his alma mater, Dartmouth College. *Dartmouth* was a pictorialist cliché, portraying a dreamlike campus replete with blurry fog, glassy water,

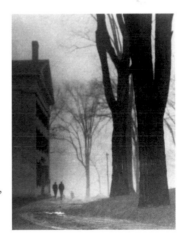

A. Ralph Steiner: Reed Hall, Fog,
Dartmouth College, Hanover,
New Hampshire, ca. 1922

intricate shadows, powdery mists, soft cottony snow, icy reflections, and intensely lit backgrounds. By the late 1920s, however, Steiner had wholly rejected the pictorialist approach and counseled straight, documentary images of the modernist machine age. Steiner remained Margaret's friend and they exchanged letters and visits. He recalled that in 1929 she tearfully told him, "You're the only person in America who doesn't think I'm a great, great photographer." Yet Margaret trusted his judgment and appreciated his technical advice. She would write that Steiner was "a superbly sharp, honest craftsman [who] caustically talked me into a fierce reversal of the viewpoint that a photograph should imitate a painting."

Margaret's big break into photojournalism came courtesy of Henry R. Luce, publisher of *Time*. Luce was starting a new business and investment publication. He was impressed by Margaret's superb Otis Steel Mill photographs. They were exactly what he had in mind for his proposed *Fortune* magazine. Luce telegraphed Margaret on May 8, 1929: "Would like to see you. Could you come to New York within a week at our expense?" Luce had his answer the next day: Yes. Margaret was thrilled that the proposed magazine would display "the best procurable industrial art . . . beautifully produced." Luce convinced her that he was serious about portraying industry and capitalism in pictures as well as in words. That was what Margaret fervently wanted to create. She felt that the depiction of industry offered the best opportunity for expressing what she believed to be the true art form of her times. She was stimulated by entering the domains where women traditionally had been excluded:

steel mills, coal mines, stockyards, meat packing facilities, agricultural-implement factories, paper mills, automobile-manufacturing plants. She was energized by the possibilities offered by extreme vantage points and unusual platforms for her camera – derricks, girders, skyscrapers, and airplanes.

Before accepting the *Fortune* job, she demanded – and got – enough freelance time to pursue advertising and commissioned work alongside the schedule that Luce and his staff would require. In the end, she sent an excited telegram to her mother announcing that she would begin work for the new magazine July 1. At the beginning of the Great Depression her salary would be $1,000 a month for half of her time. After receiving Luce's offer, Margaret wrote to her mother: "I feel as if the world has been opened up and I hold all the keys."

<p style="text-align:center">★ ★ ★</p>

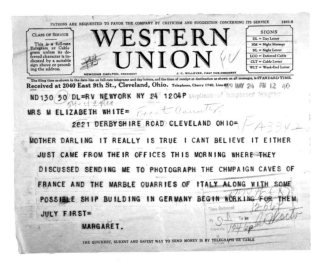

Margaret Bourke-White's Western Union telegram
to her mother with news of her new fortune
at Fortune *magazine May 24, 1929*

Once the traumatic events of her early life are taken into account, the photographs she made at the University of Michigan, Cornell University, and during her early professional career in Cleveland take on greater significance. Her campus and early career images are serene. Margaret's early architectural and landscape photography offers visions of quiet solitude, tranquility, and beauty. Her scenes are virtually unpopulated unless they were made to document specific clients. It may be that Margaret Bourke-White was giving her customers only what they were paying for, but her images mirror deep personal needs, bringing a sense of order and rationality to a sometimes confused but always intensely ambitious young life.

As an artist, Margaret asserted her independence. She wanted to be popular, noticed, and famous. She apparently realized that personal bravado and a thrilling life story added a fourth dimension to her photographs' strength and communicative quality. Her early work shows an singular visual sense stemming from innate talent, and while her first impulse may have been inspiration, she followed it immediately by perspiration. Though she was a risk-taker, her devotion to the task at hand was legendary; her work ethic and her ability to concentrate in difficult situations became legendary. She also sought out technical advice and was willing to experiment with new equipment, film, and processes. She learned very early while developing her studio business that clever employees could be indispensable, whether running her front office or laboring in her darkroom. She recruited excellent talent to assist her. Much has been made by her biographers of her ability to manipulate others and to use her good looks, tasteful dress, and

strangely affected speech patterns to advance her career. She could be gracious and charming as well as brusque and tactless.

The images of her early career would not be sufficient to ensure her fame and reputation as a twentieth-century master of photography. Only one or two among them have been reprinted in the standard Bourke-White portfolio. As a visual corpus, her early photography is very different from the work for which she is best remembered. Margaret was sensitive to the trends of her times and the tastes of her audience. She graduated from an educated, aesthetically sophisticated, and narrow audience to a mass-culture / mass-market audience. Her idiom evolved from soft-focus shots of serene nature and moody quadrangles to hard-edged, crisp industrial subjects where heroic men created wealth and abundance by taming massive structures and machines. Her mature photojournalistic work for *Life* featured the human face and form with a humanitarian sensibility. She was a globetrotter and she captured images of people, celebrity and nonentity alike, that were sometimes newsworthy, often dramatic, and always brimming with human interest. They were rarely pleasant images. As a photojournalist, she described the full spectrum of human sorrow – the rickets-ridden African-American child with flies crawling over his face; the Georgia chain gangs; portraits of weary sharecroppers; the Louisville flood victims; the fanatical Nazi crowd salutes; the wounded G.I.s in Italy's Cassino Valley; the rotting piles of naked, emaciated corpses at the Buchenwald death camp; the charred remains of prisoners who had sought to escape the twisted maze of barbed wire at the Erla death camp; the Nazi officials and

their families who committed suicide. After the Second World War, Margaret Bourke-White turned her attention to other scenes of despair and violence, photographing more searing images, such as vultures feeding on famine-stricken corpses, the squalor of refugee camps as India and Pakistan were partitioned along religious lines, and the South Korean soldier with an axe over his shoulder, laughing at the severed head of a young North Korean. These were among the images that brought her enduring fame, adulation, and financial reward. But perhaps more important, they allowed her to share compassion and sympathy with the victims.

In a final tragedy, Margaret herself fell victim to Parkinson's, a progressively debilitating disease characterized by muscular rigidity, rhythmic tremors, and loss of balance. From the mid-1950s onward, she became increasingly unable to use a camera. Toward the end, Margaret Bourke-White achieved a measure of peace as she became reconciled to mortality. She no longer ached for an audience's attention: she wanted people to view her photographs.

Margaret's life ended quietly in 1971 in Stamford, Connecticut. Now, when we look at her photographs (and there are nearly a quarter million of them), we realize they are inseparable from her own sensibilities, from the interior landscape of an audacious mind.

UNIVERSITY OF MICHIGAN

1922–1924

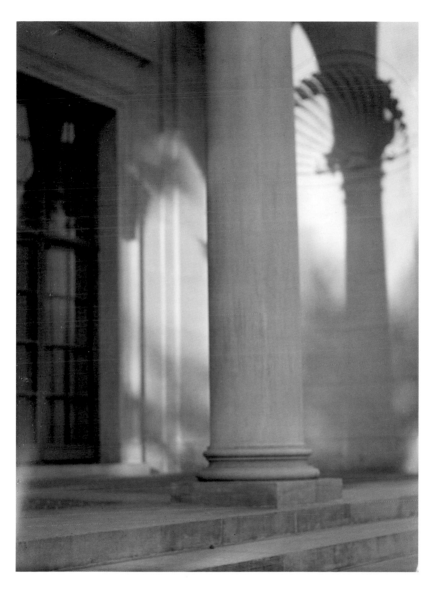

William L. Clements Library

3

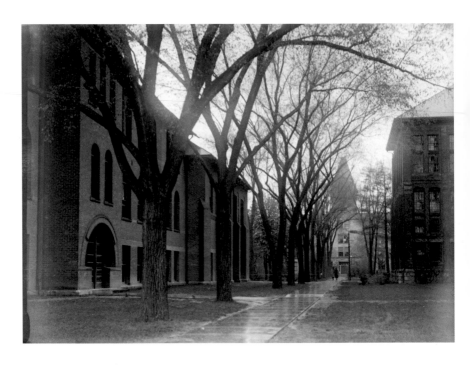

Physics Building in Rain

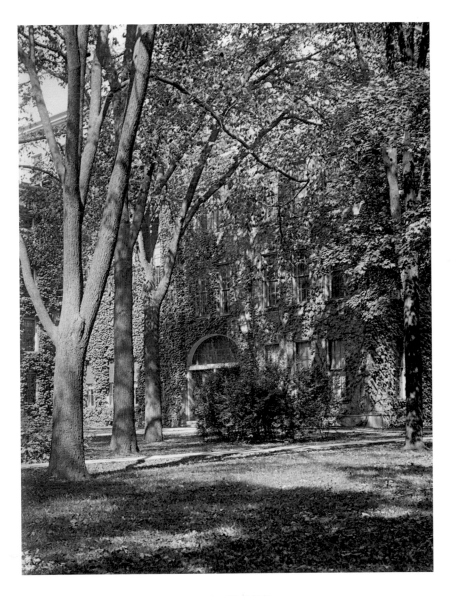

University Hall Foliage

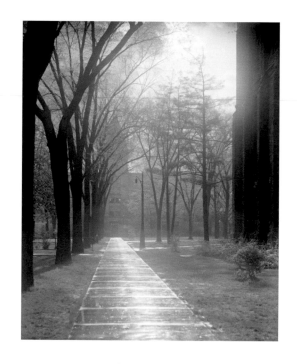

Museum Walk

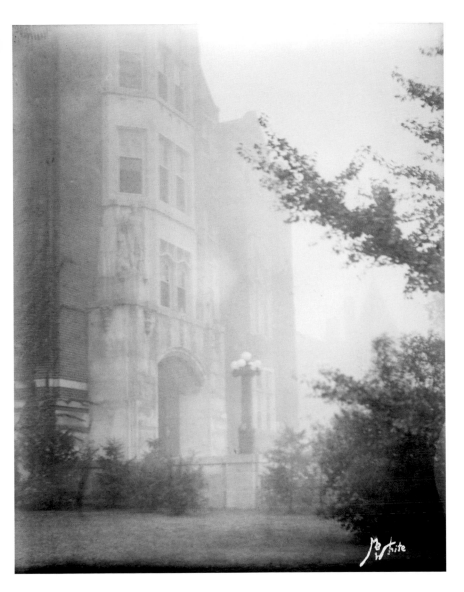

Michigan Union in Fog

7

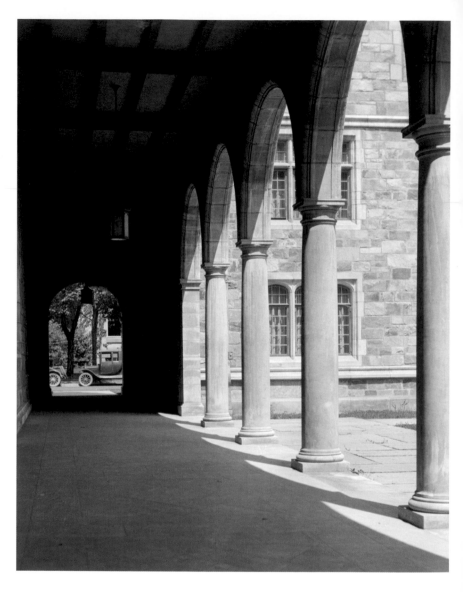

Colonnade

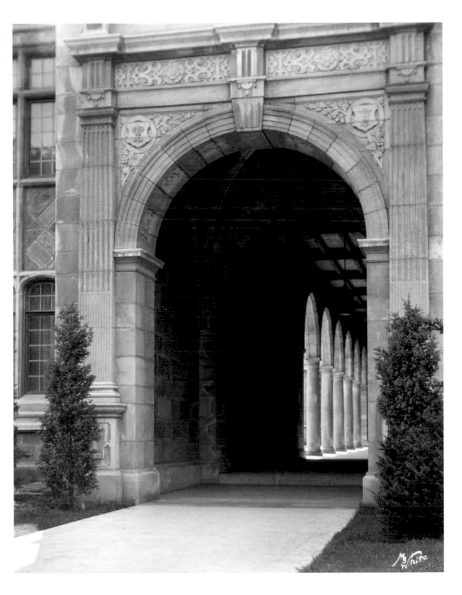

Archway

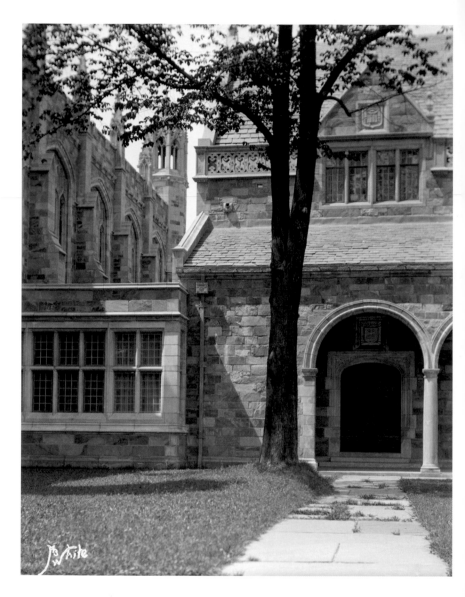

The Law Club

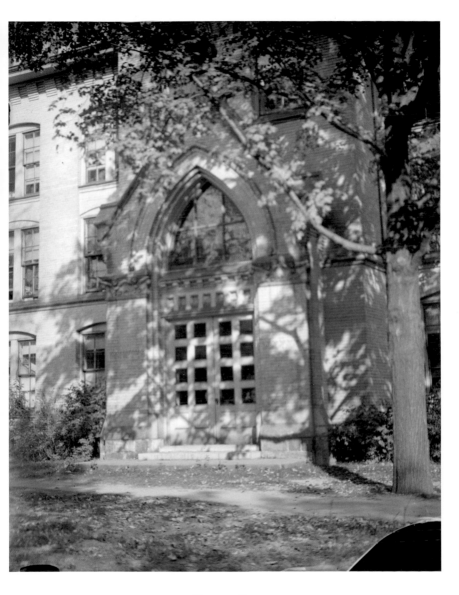

Museum Door

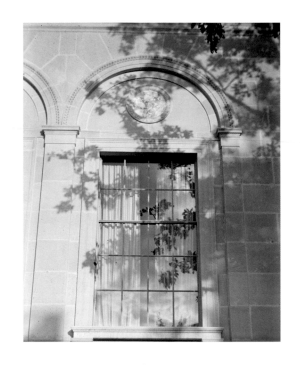

William L. Clements Library

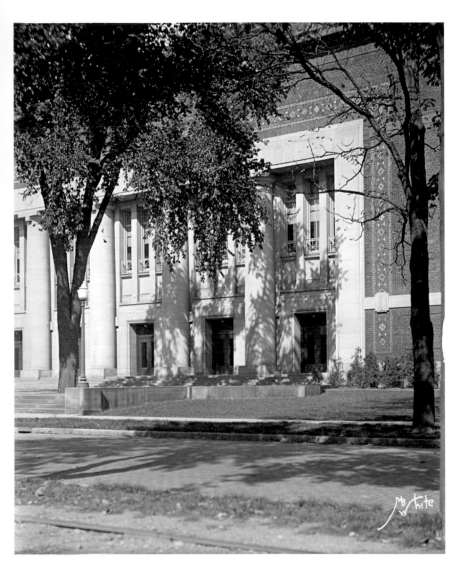

Hill Auditorium

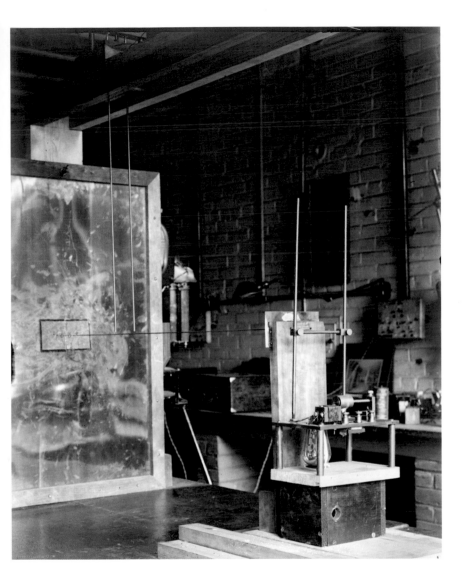

Shortwave Oscillator

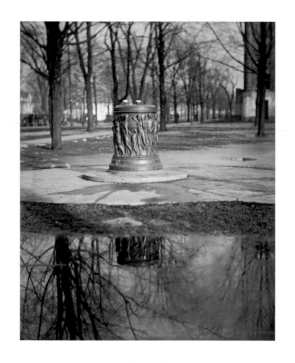

Fountain

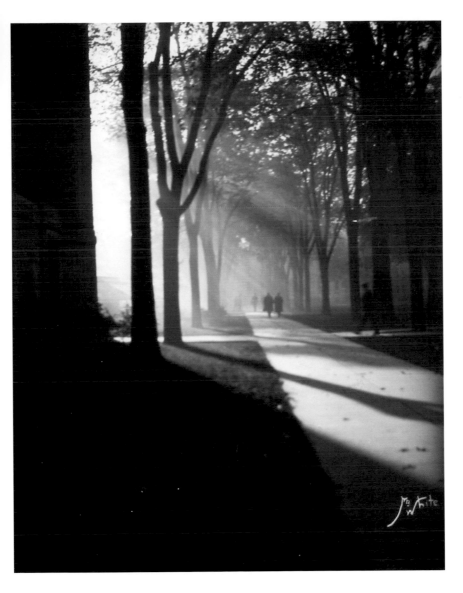

Walkway

17

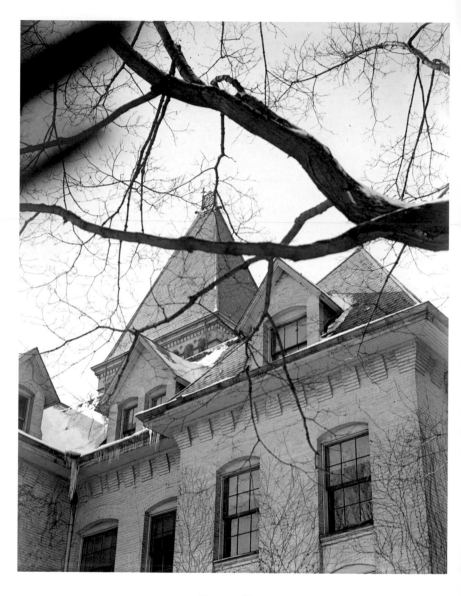

Museum Tower

18

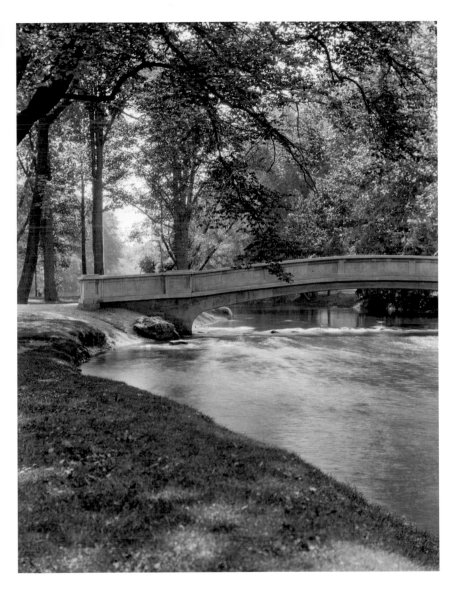

"Restful" Bridge

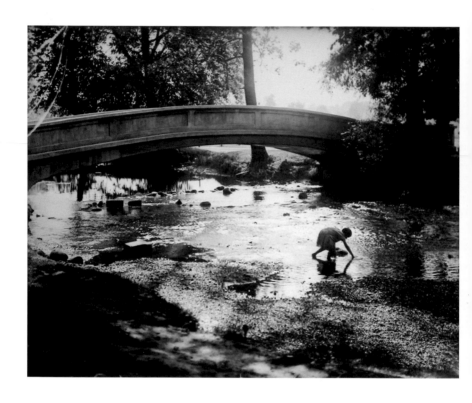

Playing Near a Bridge

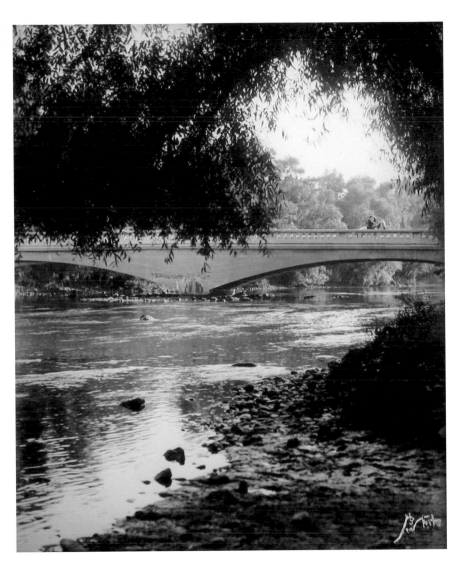

Fragment of War Bridge with Horse and Rider

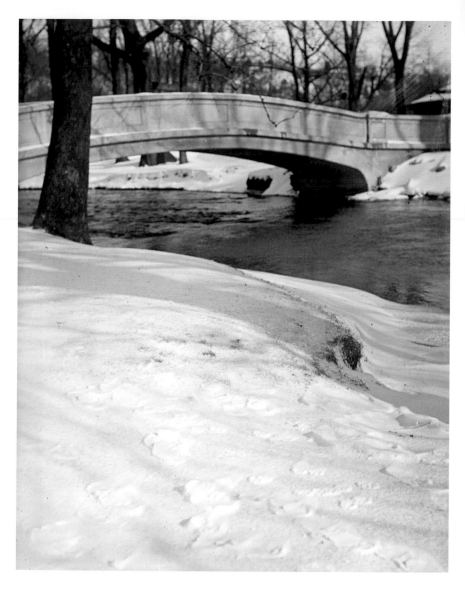

Winter at Campus Bridge

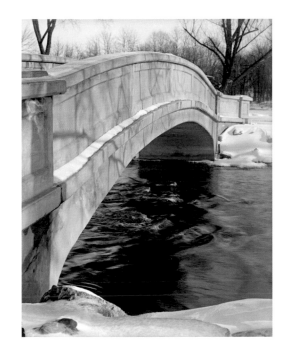

Campus Bridge Over Stream Riffles

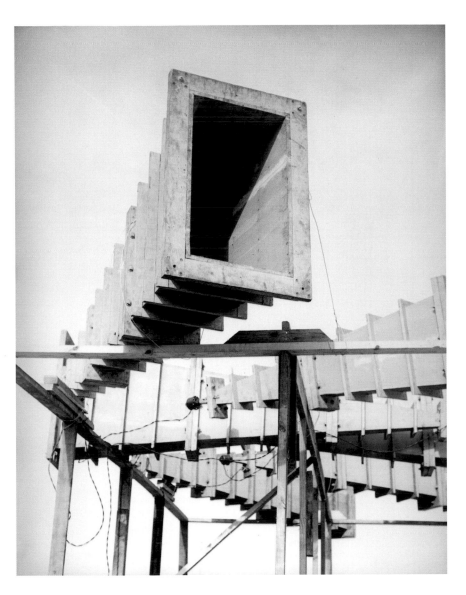

Loudspeakers

CORNELL UNIVERSITY
1926–1927

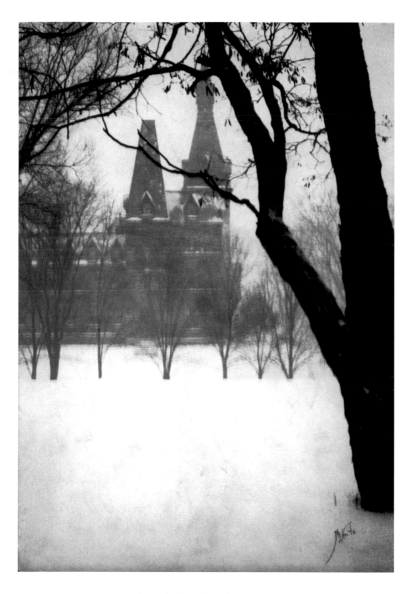

Sage College in a Snowstorm

Ithaca's West Hill from Libe Slope

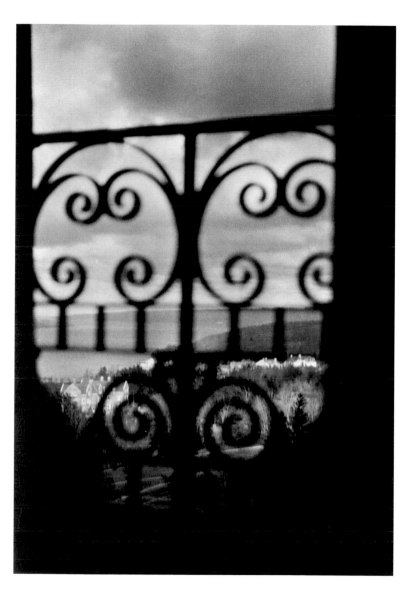

View of Cayuga from the Library Tower

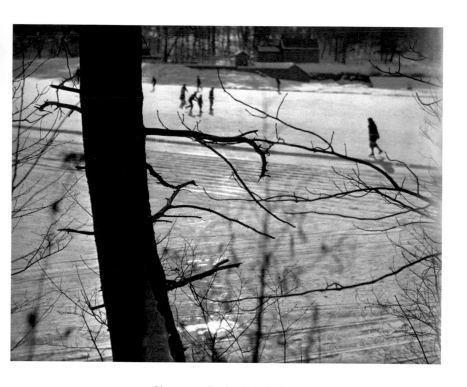

Skaters on Beebe Lake, Winter

33

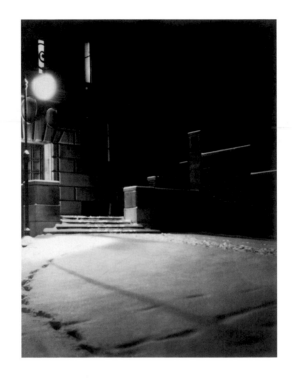

Entrance to Baker Laboratory at Night

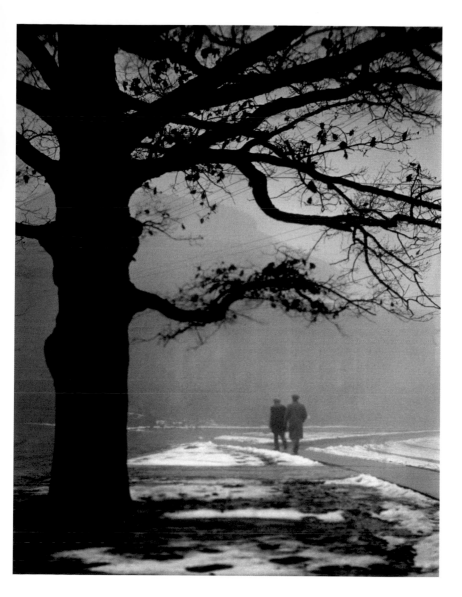

Bailey Hall in Fog

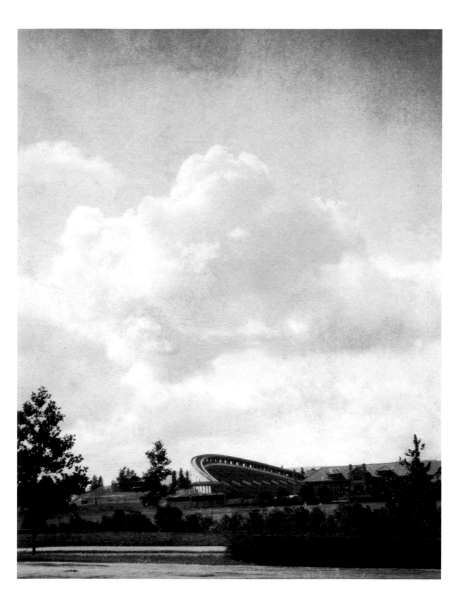

Schoellkopf Crescent

37

Garden in Ithaca, New York, Summer

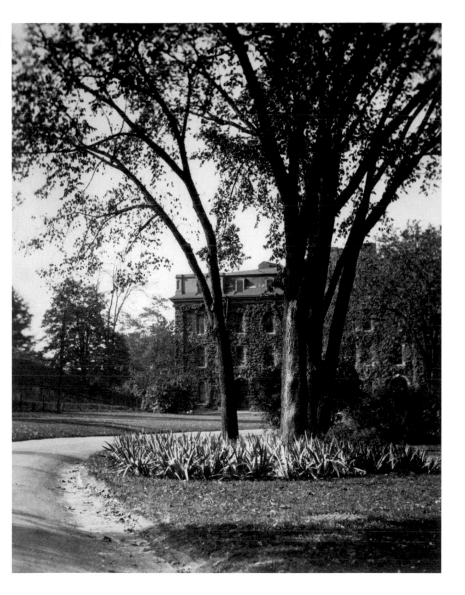

Cascadilla Under the Elms

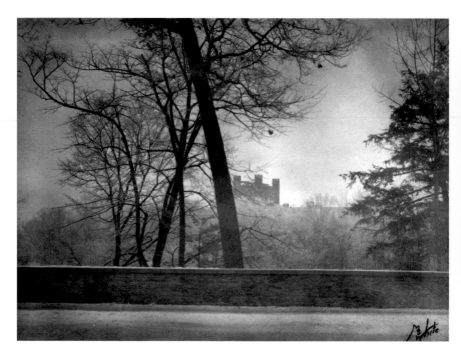

Prudence Risley Hall Across Fall Creek Gorge

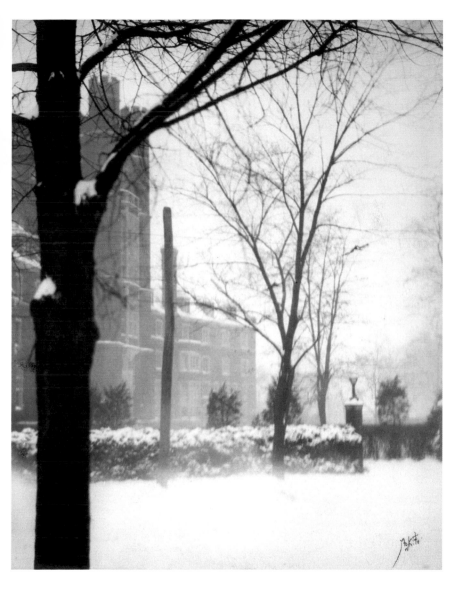

Risley Hall – Wintertime

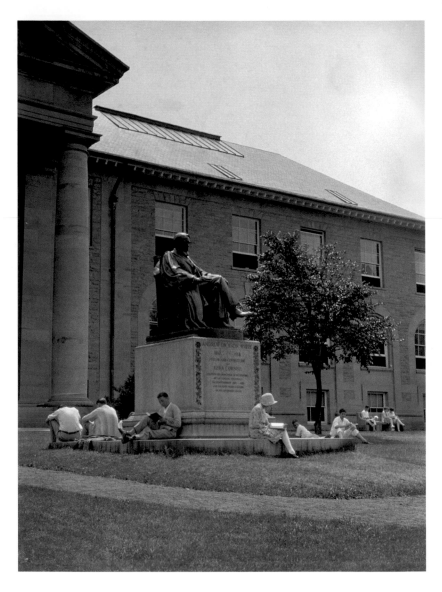

First President Andrew Dickson White Statue

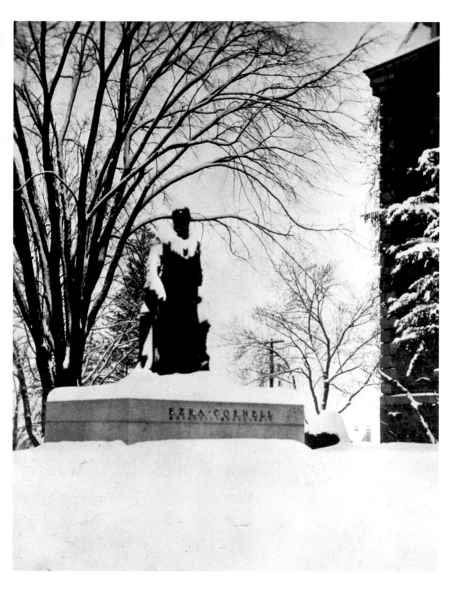

Founder Ezra Cornell Statue, Arts Quadrangle

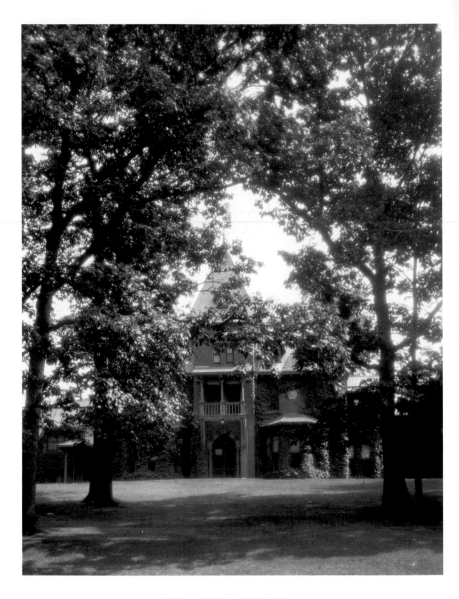

Andrew Dickson White House

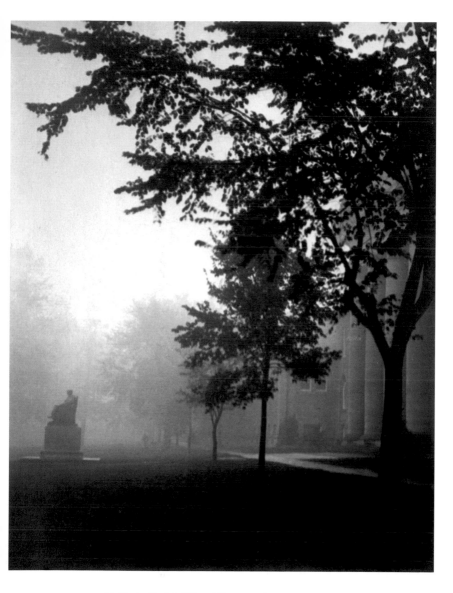

Goldwin Smith Pillars Through the Morning Fog

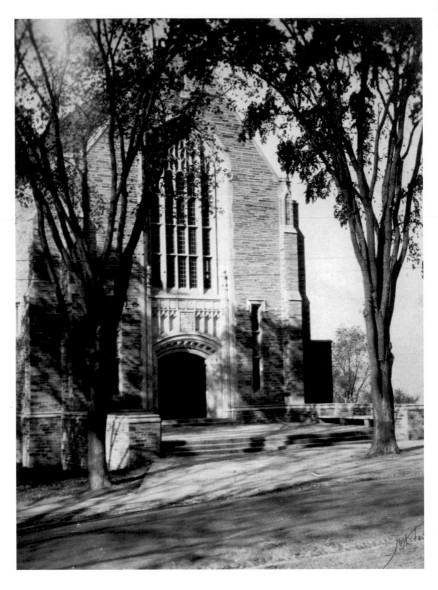

Willard Straight Hall Under Arch of Elms

46

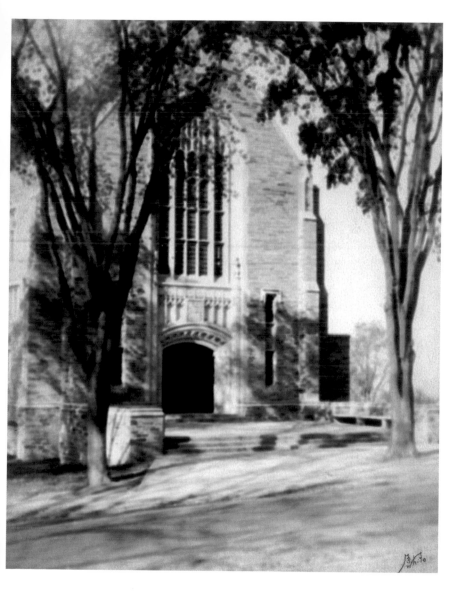

Willard Straight Hall Under Arch of Elms

47

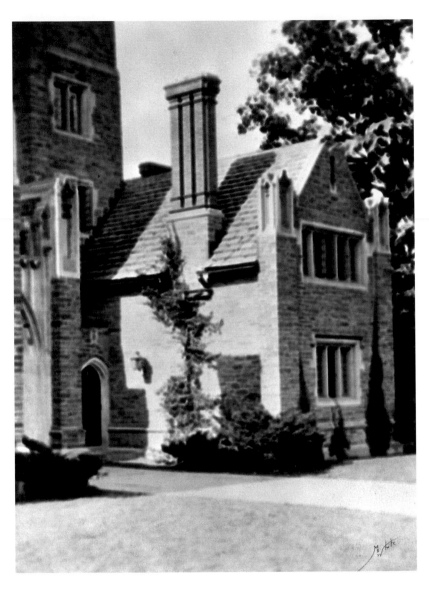

Right Wing of Baker Dormitory

48

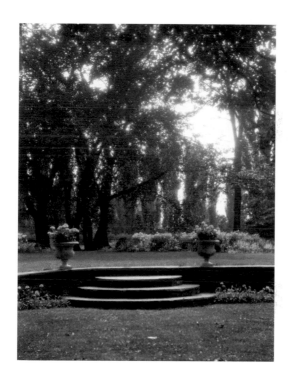

Livingston Farrand Garden

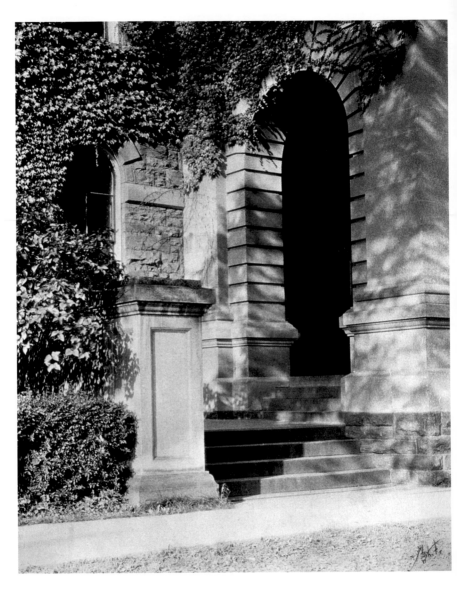

Entrance Arch Under Sibley Dome

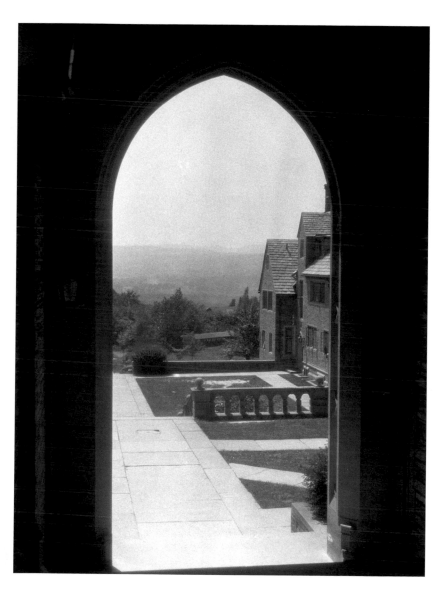

West Campus Residence Halls

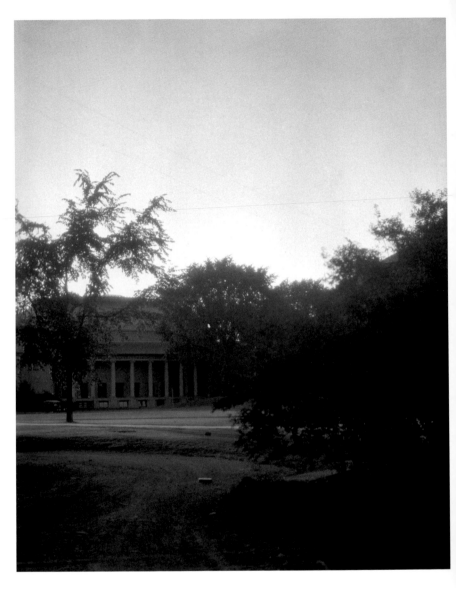

Bailey Hall

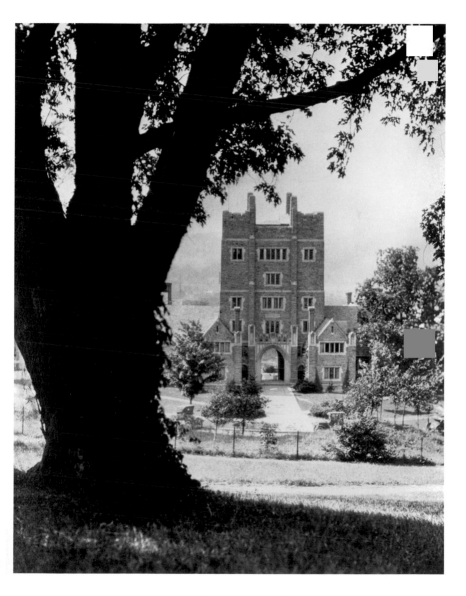

Baker Tower from the Hill

53

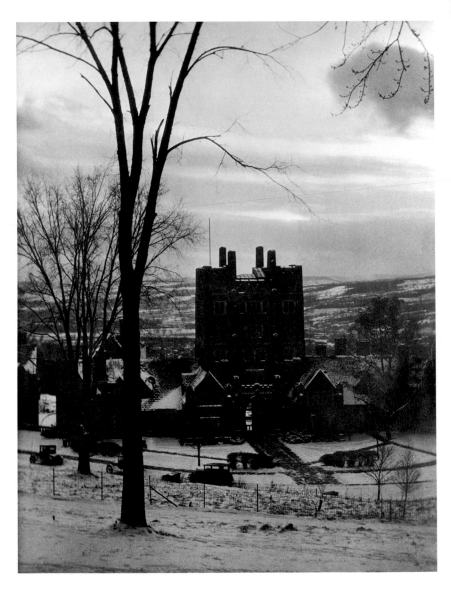

Baker Tower from the Hill, Winter

54

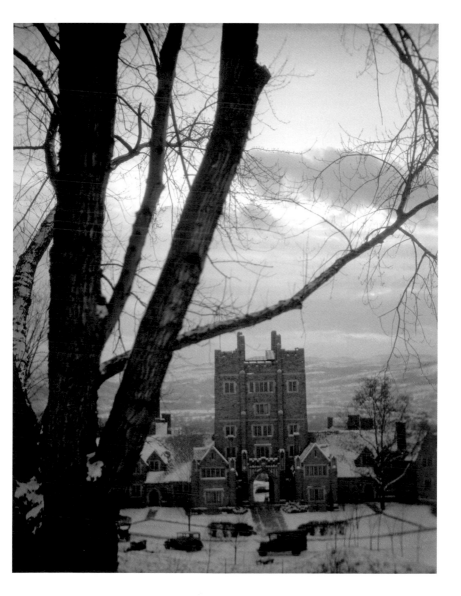

Baker Tower from the Hill, Winter

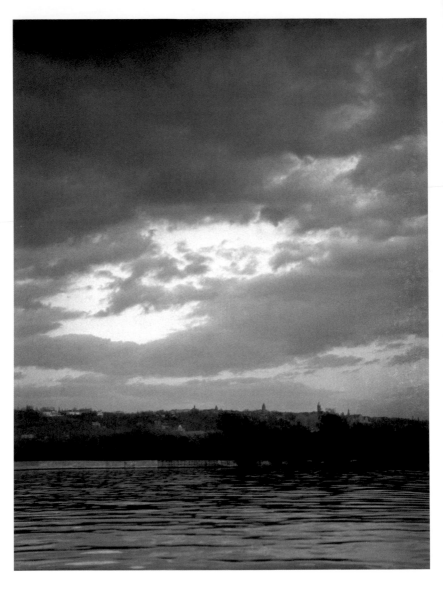

A Campus Skyline at Twilight

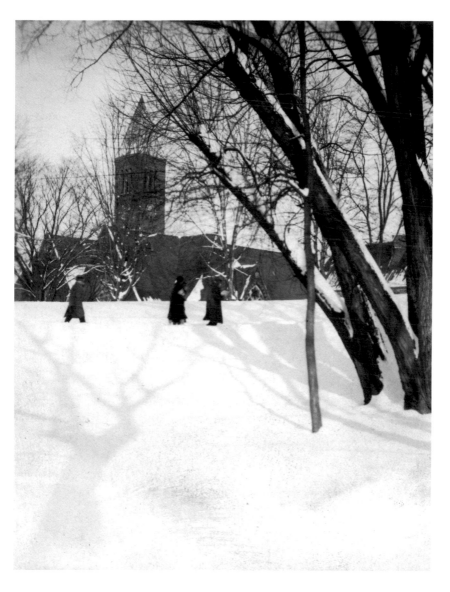

Jennie McGraw Tower and Sage Chapel, Winter

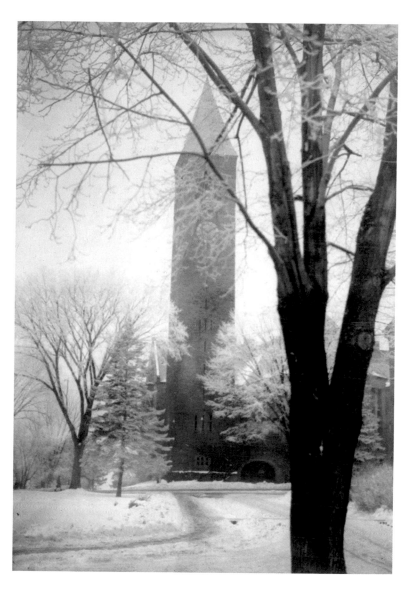

Library Tower in the Mist, Winter

59

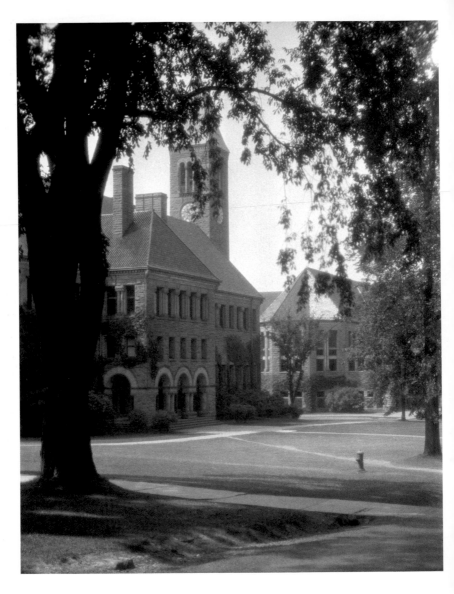

Boardman Hall, Jennie McGraw Tower, and Uris Library

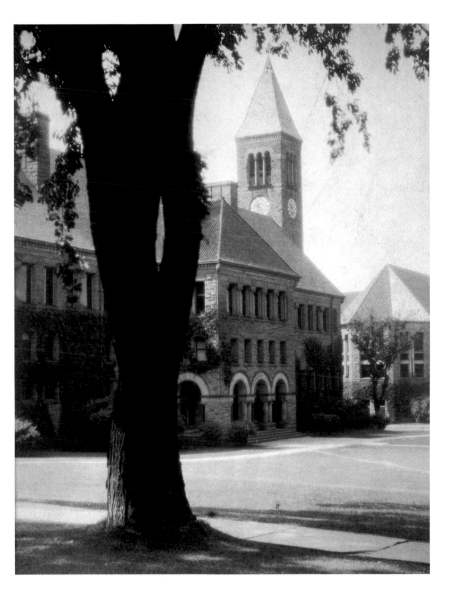

Boardman Hall, Jennie McGraw Tower, and Uris Library

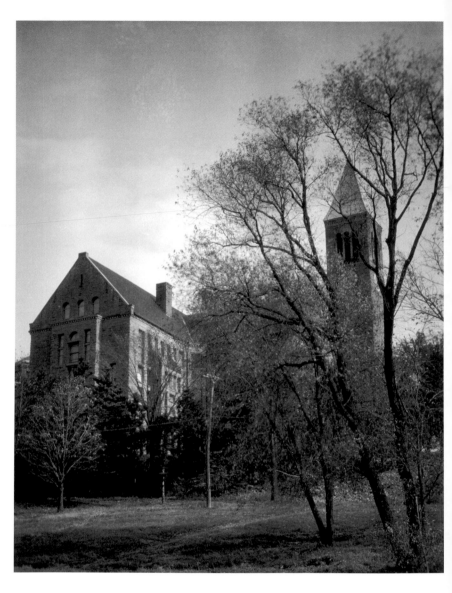

East View of Uris Library and Jennie McGraw Tower

*Morrill Hall, Uris Library, and
Jennie McGraw Tower, Winter*

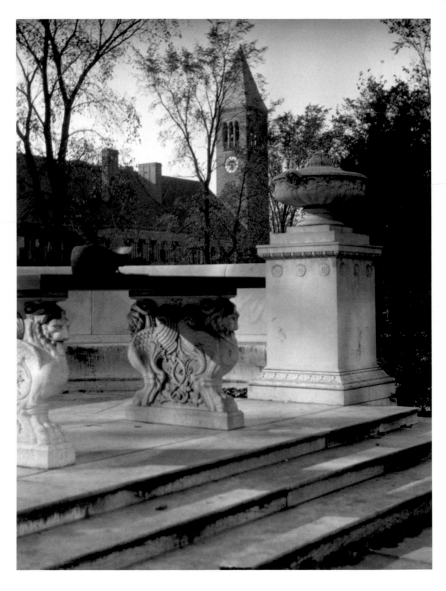

Sundial Showing Library Tower

64

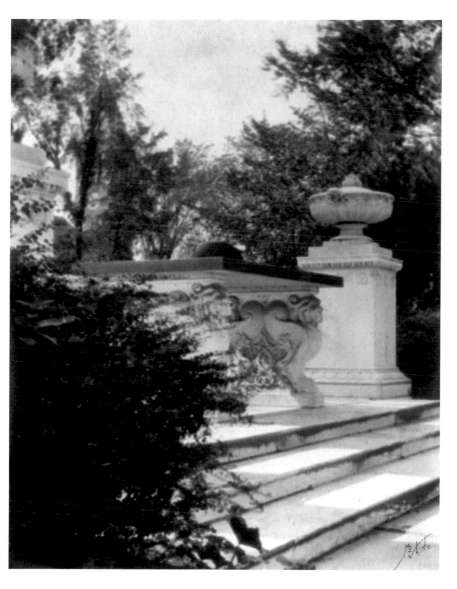

Sundial Showing Library Tower

Twin Entrances of Sage Chapel

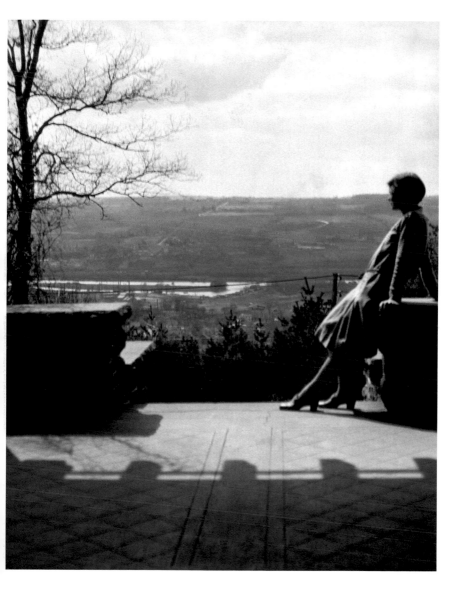

View of Ithaca's West Hill from Libe Slope

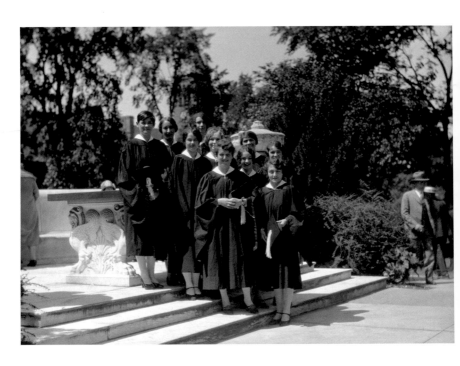

Graduation Group

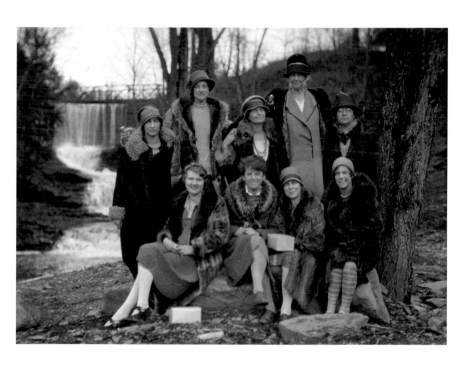

Group of Women

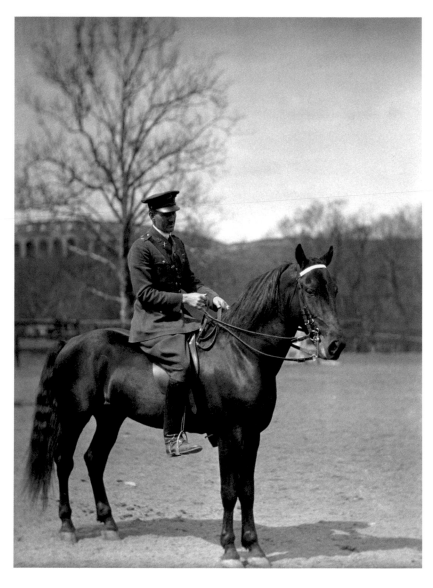

Reserve Officer Training Corps Horseman, Schoellkopf Crescent

Canine, Ithaca, New York

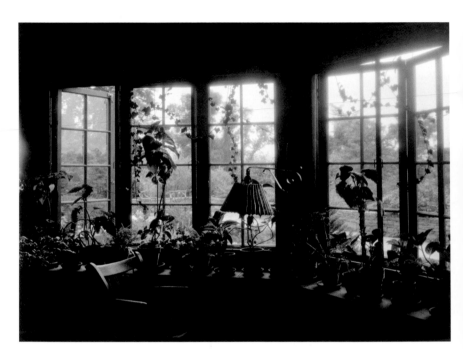

Home Interior, Ithaca, New York

Theatrical Trio

73

Cornell University Doorway

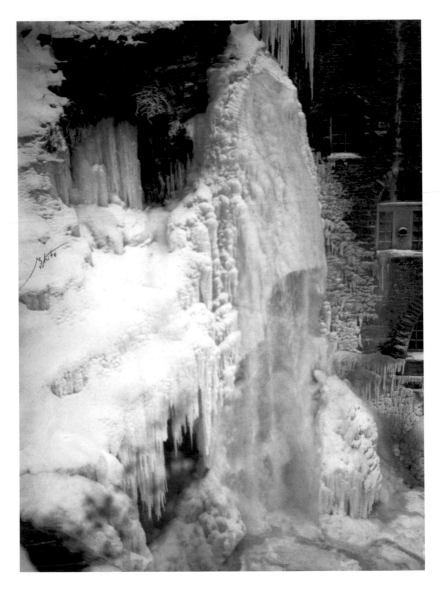

Triphammer Falls, Hydraulics Lab, Winter

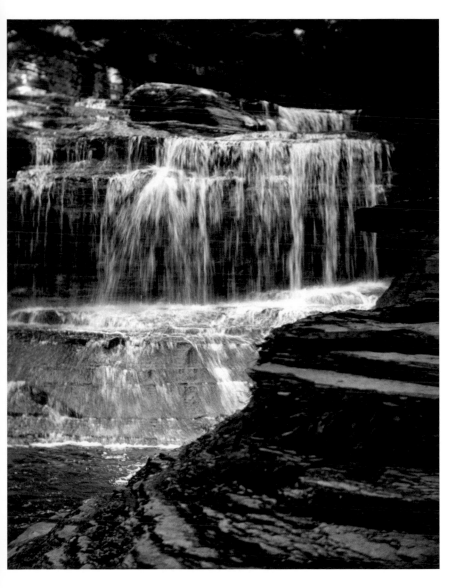

Waterfalls, Cornell University Gorge

77

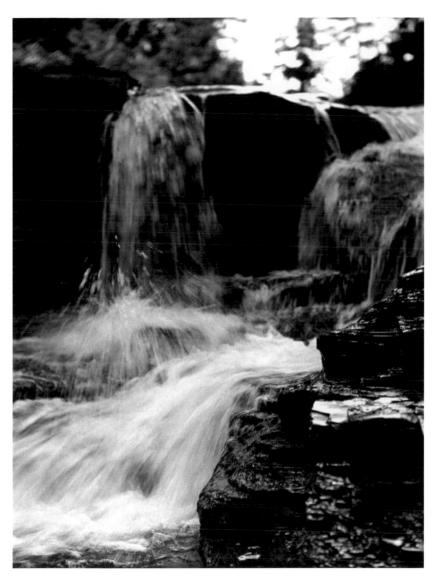

A Glimpse of Cascadilla Falls Beneath the Stone Arch Bridge

CLEVELAND, OHIO
1927–1930

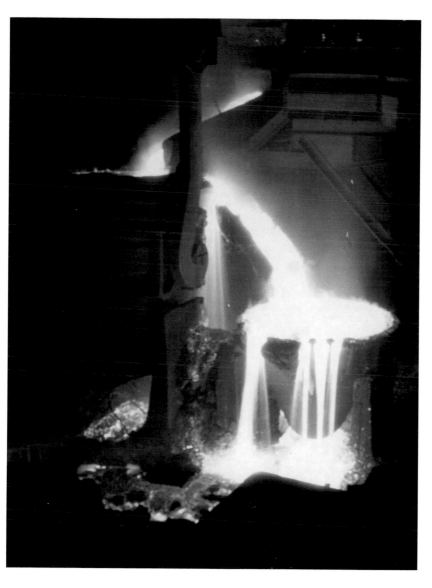

Molten Steel, Otis Steel Mill

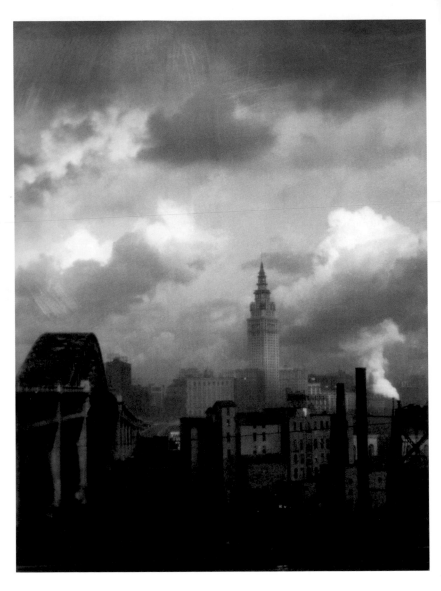

Terminal Tower and High Level Bridge

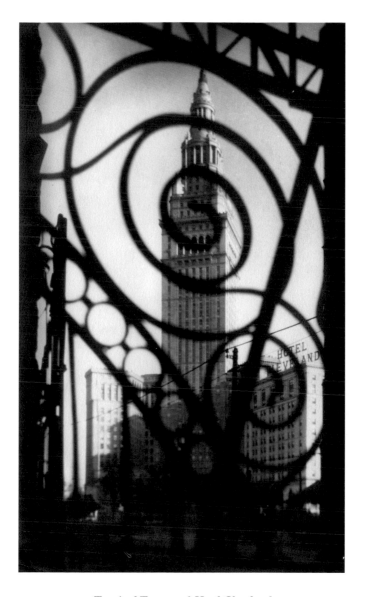

Terminal Tower and Hotel Cleveland

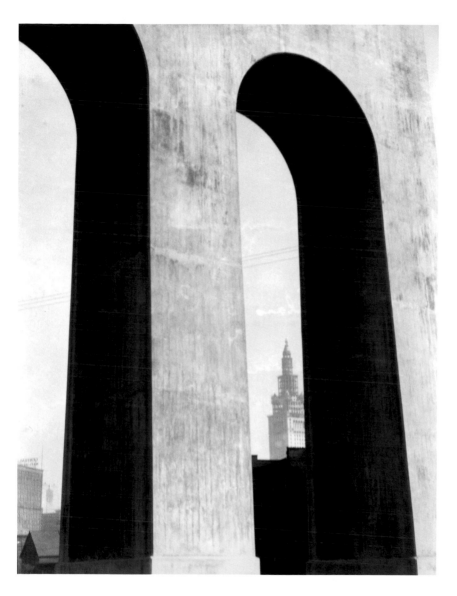

Terminal Tower Beyond Railroad Trestle

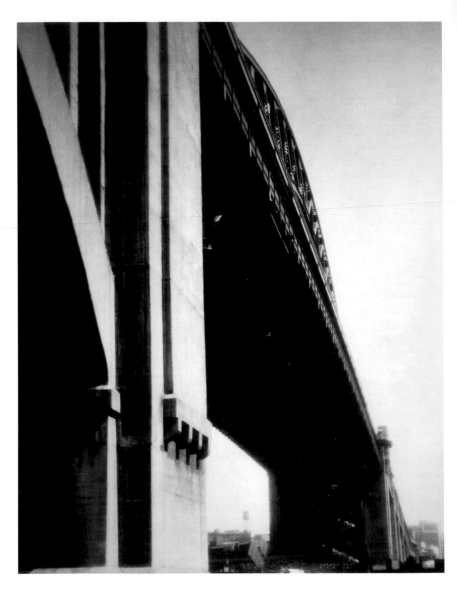

Low View of High Level Bridge

ACKNOWLEDGMENTS

For their generous support and assistance: Carolyn Davis, Robert Doherty, David R. Godine, Carol Kammen, M. Peter Keane, Alan Littell, Kasia Maroney, Pearle Nerenberg, Carl W. Scarbrough, and Linda Van Buskirk.

Limited-edition prints of Margaret Bourke-White's early photographs are available for purchase from her estate. For information, or to place an order, please contact Toby White at 2196 Commons Parkway, Okemos, Michigan 48864 or at tobywhitelaw@yahoo.com.

PHOTOGRAPH CREDITS

Great care has been taken to trace all owners of copyright material included in this book. If any have been omitted or overlooked, acknowledgment will gladly be made in future printings.

Page XII (top): Maynard P. White, *Clarence H. White*. (Aperture, Inc., Millerton, 1979). Page XII (bottom): Marianne Fulton (ed.), with Bonnie Yochelson, and Kathleen A. Erwin, *Pictorialism into Modernism: The Clarence H. White School of Photography*. (Rizzoli, New York, 1996). Page XXXI: A. Ralph Steiner, *Dartmouth* (The Albertype Co., Brooklyn, 1922). Pages II, X, XIV, XVI, XVII, XXV, XXIX, XXXIII, 3–25, 29, 30, 33, 35–38, 40, 42–44, 48–52, 54–57, 60, 62–64, 67–79, 83–88: Syracuse University Library, Special Collections Research Center. Photographs © The Estate of Margaret Bourke-White. Page XXII: *Cornell Alumni News*. Pages 31, 46, 53, 61, and 65, gifts of Melita Taddiken; pages 34, 39, 41, 45, 47, and 59, gifts of Rachel Childrey Gross; page 66, gift of Caren and Roger Weiss, courtesy of the Herbert F. Johnson Museum of Art, Cornell University. Photographs © The Estate of Margaret Bourke-White.

A NOTE ON THE TYPE

Margaret Bourke-White has been set in Plantin, a face cut for Monotype in 1913 under the direction of Frank Hinman Pierpont. The fruit of Pierpont's research in the collection of the Plantin-Moretus Museum in Antwerp, Plantin is based on types cut in the sixteenth century by the peripatetic French typographer Robert Granjon. Unlike the more studious revivals released during Stanley Morison's tenure at Monotype, Plantin was freely adapted to the demands of modern printing: its strokes were thickened and its descenders shortened, making it a popular type for printers of periodicals. In fact, Plantin was so successful in this realm that it would later serve as one of the models for Morison's own Times New Roman. A face of considerable heft and warmth, Plantin was particularly popular among European printers and was one of the first types to be adapted for use in offset lithography.

* *
*

Design and composition by
Carl W. Scarbrough

BIBLIOGRAPHY

Bourke-White, Margaret. *Portrait of Myself*. New York: Simon and Schuster, 1963.

Brown, Theodore M. *Margaret Bourke-White, Photojournalist*. Ithaca: Andrew Dickson White Museum of Art, Cornell University, 1972.

Callahan, Sean. *Margaret Bourke-White: Photographer*. Boston: Little Brown, 1998.

————, ed. *The Photographs of Margaret Bourke-White*. Greenwich, Connecticut: New York Graphic Society, 1972.

Goldberg, Vicki. *Margaret Bourke-White: A Biography*. New York: Harper and Row, 1986.

Horton, Sam. "The Eleventh Commandment and Margaret Bourke-White." Cornell University: Carl A. Kroch Library, Rare and Manuscripts Collections #47-1-2276, n.d.

Rubin, Susan Goldman. *Margaret Bourke-White: Her Pictures Were Her Life*. New York: Harry N. Abrams, Inc., Publishers, 1999.

Silverman, Jonathan. *For the World to See: The Life of Margaret Bourke-White*. New York: Viking Press, 1983.

Stebbins, Theodore E., Jr., and Norman Keyes, Jr. *Charles Sheeler: The Photographs*. Boston: New York Graphic Society, 1987.

Steiner, A. Ralph. *Dartmouth*. Brooklyn: The Albertype Co., 1922.

White, Maynard P. *Clarence H. White*. New York: Aperture, Inc., Millerton, 1979.